How to Rule at Photo-graphy

50 Tips and Tricks for Using Your Phone's Camera

Illustrations by Rachel Harrell

CHRONICLE BOOKS

SAN FRANCISCO

Library of Congress Cataloging-in-Publication Data available.

ISBN: 978-1-4521-7757-1

Manufactured in China.

MIX
Paper from
responsible sources
FSC™ C008047

Design and illustration by **Rachel Harrell**.

10 9 8 7 6 5 4 3 2

Chronicle books and gifts are available at special quantity discounts to corporations, professional associations, literacy programs, and other organizations. For details and discount information, please contact our premiums department at corporatesales@chroniclebooks.com or at 1-800-759-0190.

Chronicle Books LLC
680 Second Street
San Francisco, California 94107

www.chroniclebooks.com

A roll of masking tape turns almost anything into a tripod.

2.

MAKE SURE YOUR THUMB ISN'T COVERING THE CAMERA LENS.

3.

Dont be dumb.

Don't try to take a photo if it could
potentially be dangerous (like if you are driving
or performing open-heart surgery).

4.

CLEAN YOUR LENS!

People laughing: Take a gazillion pictures of that.

6.

CONNECT WITH YOUR PORTRAIT SUBJECTS. MAKE THEM COMFORTABLE.

Pay attention to background when shooting a portrait.

Clear away clutter. A simple solid color adds a lot.

8.

TAKE PICTURES AT THE BEGINNING AND THE END OF A MOMENT, EVENT, OR SPECIAL DAY.

9.

If you're asking a stranger to take your photo, make it as easy as possible for them!

1. Tell them exactly where to stand so
they get the angle you want.
2. Have your camera on the right settings.
3. If it's a group photo, make sure everyone is already
in position before you flag the stranger down.

10.

HOLD A TREAT OR
A TOY ABOVE YOUR
CAMERA TO GET YOUR
FURRY BABY OR
HUMAN BABY TO LOOK
AT THE CAMERA.

FINDING YOUR BEST ANGLE

1. $AB \cong AB$

1. REFLEXIVE PROPERTY OF Equality.

1. THE ANGLE BISECTOR DIVIDES THE ANGLE INTO TWO CONGRUENT ANGLES

11.

I'm going to let you in on a little secret:

Taking the perfect selfie is ALL about the angles. No matter how you're looking that day, if you choose your angles wisely, any photo you take of yourself is going to look Beyoncé-level flawless. Turn on your front-facing camera and try a bunch of different angles, snapping photos along the way. Once you've taken a sufficient number of selfies, check them out and see which angles you love, and which you absolutely hate. And there you have it, all of your best angles in a snap (or 10, or 20). Pro tip: Almost nobody has perfected a selfie taken from below.

12.

BEFORE TAKING A SELFIE, DO A QUICK TOOTH CHECK!

13.

When taking a photo of yourself, make sure you stick out your neck to prevent the dreaded double chin.

14.

STRONG ARMS!

Don't lay your arms flat down. Put your hands
on your hips to give yourself Michelle Obama arms.

Brightness:

Contrast:

ALMOST EVERY PHOTO CAN BE IMPROVED BY INCREASING THE BRIGHTNESS AND CONTRAST JUST A SMIDGE.

16.

Capture the smallest details.

Get up close to the object or person you are photographing and test your camera's focus. How far or near you are to the subject can drastically change the lighting and dimensionality of a photo.

17.

ZOOM WITH YOUR FEET.

Your camera's zoom feature can be handy for taking pictures of things that would be physically impossible or unsafe to get closer to. But it also makes your pictures grainier and less visually pleasing. Whenever possible, walk nearer to your subject until you're able to frame just the shot you want.

18.

Know that flat lay is your friend.

That viral pic of Kendall Jenner's heart hair? Every food blogger photo? That's flat lay and it's the easiest way to elevate your photo game. Hold your phone on a level plane with your subject and shoot. Don't be afraid to get up as high as necessary—stand on a chair or directly over the subject—just make sure you're stable and *then* snap away!

INHALE

EXHALE

* CLICK *

19.

Take the photo at the bottom of your exhale.

Breathe in.

Breathe out.

Hold it.

Press the button.

Wobble-reduction and mindfulness, all in one.

You can save
an Instagram-
edited photo
without posting
it by putting
your phone on
airplane mode.

21.

Invest in a stepladder.

It's the best way to take above shots of products, books, sets, etc., when you don't have a professional studio.

22.

TAKE MULTIPLES OF EVERYTHING! NEVER ASSUME THAT YOU CAPTURED THE MOMENT IN ONE SHOT.

SHOW SCALE.

Does that huge rock look less impressive in the photo than you thought it would? Add something to show scale—a person or an object everyone will recognize, like a flower, or even your feet.

24.

Don't overedit; if you do, your photos will look dated sooner.

Moon

Cairo

Nashville

Crema

25.

WHEN APPLYING A FILTER, SCALE IT BACK TO AT LEAST 50 PERCENT.

26.

Photos in cloudy weather are the bomb.

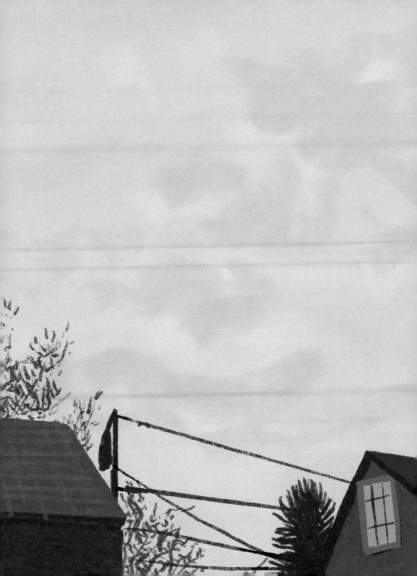

27.

CAPTURE ORDINARY MOMENTS.

28.

Find your light.

Take a moment to locate the sun (or,
if you're inside, the lamp), and then shoot
away from it. Backlit is not a good look.

29.

NATURAL LIGHT IS THE BEST LIGHT.

BE CONSCIOUS
OF SHADOWS.

Look for window light and shade to get rid of
distracting shadows, or find harsher light to make
interesting, dramatic shadows.

31.

If you're in a photo and you are not squinting, you're probably backlit.

32.

FIGURE OUT WHITE BALANCE: IT WILL MAKE YOUR PICTURES 100 TIMES BETTER.

Correctly setting the white balance ensures that the white and gray parts of your photo look neutral and don't have a color cast to them. Every light source has a different color temperature, ranging from cool to warm. Our eyes naturally adjust to different lighting so we see white objects as white, but digital cameras don't. That's why sometimes your indoor photography will have a yellow cast, or your outdoor shots will look a little blue. Correcting the color will make your photos look crisper and more natural.

33.

BALLOONS MAKE COLORED SHADOWS. TAKE A PICTURE OF THAT.

34.

Never underestimate a black-and-white photo.

Nothing says peace and quiet like a photo taken in the early morning.

KEEP STRAIGHT LINES
LIKE A WINDOWSILL
OR TABLETOP AWAY
FROM YOUR PHOTO'S
EDGE UNLESS YOU'RE
WILLING TO REALLY
LINE IT UP.

A

B

C

D

37.

Experiment with cropping, both while composing your shot and after you take your shot.

38.

TURN ON THE GRID FEATURE ON YOUR PHONE'S CAMERA AND THEN USE IT TO LINE UP YOUR SHOT.

For straightforward shots, put the focus in the center.
For something artier, try off-center focus.

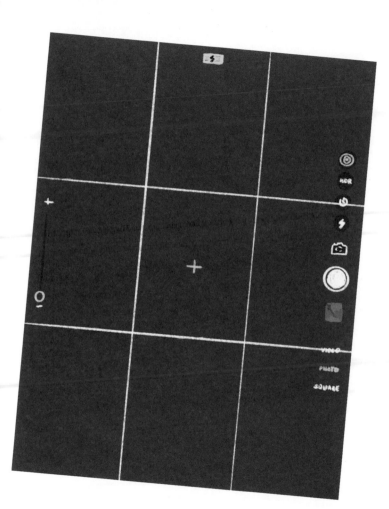

39.

Watch out for perspective distortion.

Move two steps back, to the side, up and down—
whatever it takes to create balance.

Some apps have a skew-perspective feature.

If you take a photo of a rectangle-shaped object (like a picture frame or a window) and it's looking askew, try using this feature to fix it.

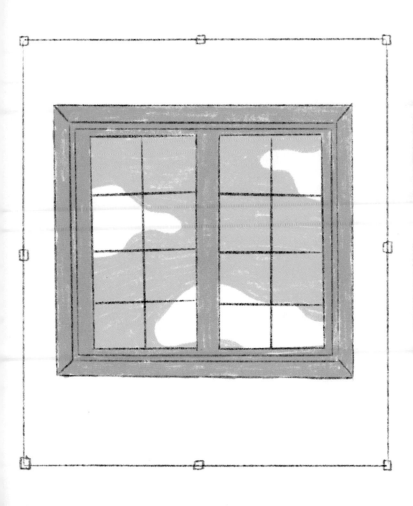

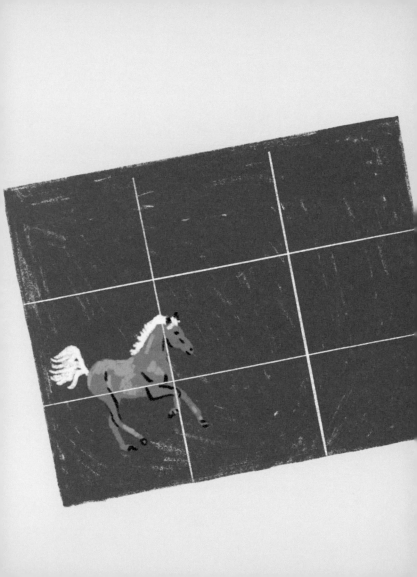

41.

THE RULE OF THIRDS:

When framing your shot, imagine two vertical lines and two horizontal lines dividing your field of vision into thirds in either direction. The lines create a grid that breaks up an image into nine equal parts. If you place important photographic elements (the horizon line, landmarks, etc.) along these lines, or at the points where they intersect, it will help create a more dynamic, interesting photograph.

42.

Play around with your camera's editing tools. Have fun and try new things—no one has to see *it* if you hate it.

43.

Don't be afraid to experiment with different photo props.

Maybe it's a cactus, your favorite candy bar,
or even your cat's paw. Whatever it is, you'll never
know what you'll like until you test it out.

44.

Experiment with vantage points. Stand on a chair, lie on your stomach, lie on your back.

45.

DON'T FORGET TO BE IN THE PRESENT MOMENT!

Don't spend so much time taking pictures
you miss out on the main event: life.

When photographing something in motion, take a burst of shots in quick succession.

Hint: Most phone cameras have a setting that allows you to do this with just one touch.

BE CURIOUS. PAUSE. LOOK DOWN ALLEYS, THROUGH WINDOWS. LOOK UP.

48.

TAKE PHOTOS OF SUBJECTS YOU LOVE,

whether that's food, your BFF, or your dog. It'll help
you find the beauty in every photo you take.

IN GROUP SHOTS, PUT PEOPLE WITH BIG FACES IN THE BACK AND PEOPLE WITH SMALL FACES IN THE FRONT.

50.

EVEN STATIC SCENES CAN SHOW MOVEMENT AND LIFE.

Use shadows, clouds, body shapes, etc., to show that this is a moment in time and that the world keeps moving after the "click."

Thank you to our extremely knowledgeable and creative crew of contributors:

Natalie Butterfield

Victoria Chao

Sahara Clement

Sarah Lin Go

Rachel Harrell

Kristen Hewitt

Rebecca Hunt

Zaneta Jung

Deanne Katz

Caitlin Kirkpatrick

Mirabelle Korn

Meghan Legg

Magnolia Molcan

Viniita Moran

Iris Mori

Rachel Nuzman

Michelle Park

Bridget Watson Payne

Dena Rayess

Olivia Roberts

Janine Sato

Allison Weiner

Jennifer Yim